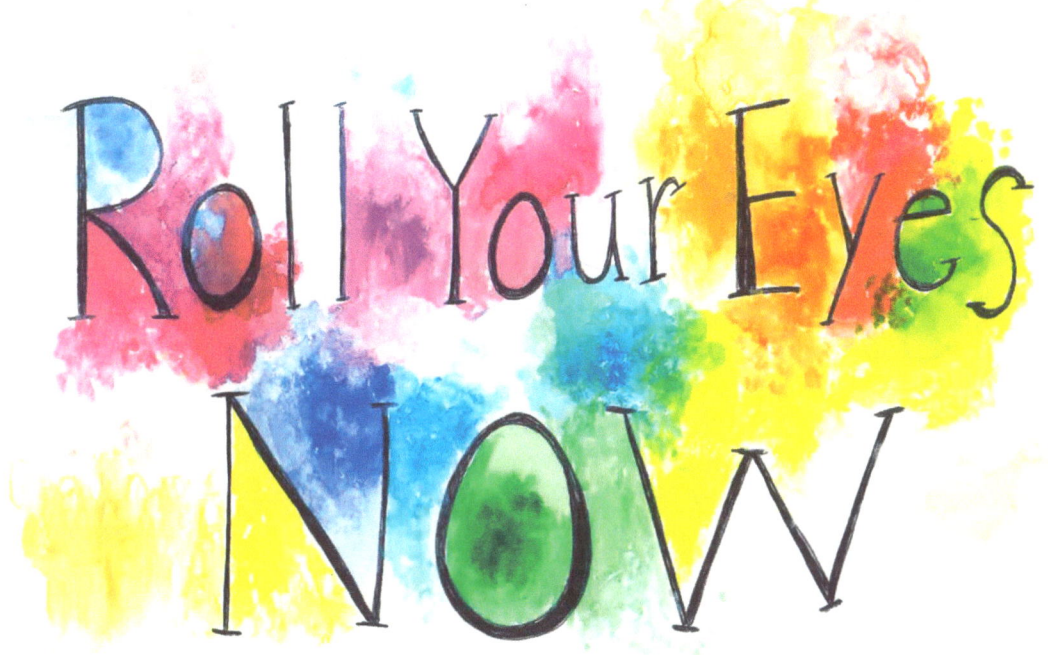

Roll Your Eyes Now

puns by
DAVE WALDROP

illustrations by
ALMA RUSS

To Edna, Erica, Ella, Kendall, Magnolia- Also to our beloved mothers, Sylvia B. Sutton and Lillie W. Pannell who sustained and inspired us all.

Special thanks go out to Ron Waldrop, Brad Waldrop, Scott Sutton, Keith Shuler, John Roper, Dr. Robert M. Rigdon, Michael Revere, Mark Jamison, Malcomb Holcombe, Robert Carter, and Dr. Gary Carden. Their individual and collective encouragement has been priceless.

Alpharetta, GA

Copyright © 2021 by Dave Waldrop

All rights reserved. No part of this book may be reproduced or transmitted in any form or by any means, electronic or mechanical, including photocopying, recording, or any information storage and retrieval system, without permission in writing from the author.

ISBN: 978-1-6653-0212-8 - Paperback
ISBN: 978-1-6653-0213-5 - Hardcover

These ISBNs are the property of Lanier Press for the express purpose of sales and distribution of this title. The content of this book is the property of the copyright holder only. Lanier Press does not hold any ownership of the content of this book and is not liable in any way for the materials contained within. The views and opinions expressed in this book are the property of the Author/Copyright holder, and do not necessarily reflect those of Lanier Press.

Printed in the United States of America 090121

∞This paper meets the requirements of ANSI/NISO Z39.48-1992 (Permanence of Paper)

FOREWORD
by Brad B. Waldrop

Dave Waldrop is my dad. For as long as I can remember hearing and understanding words, I can remember hearing Dad's puns. The modern-day term often used for puns is "Dad jokes". For me, of course, this is literal.

I recently became a father myself. It sometimes seems that references to "Dad jokes" are slightly pejorative; as if Dads can't come up with better jokes. Now, Dad and I both resemble that remark.

The truth is, Dad has used puns to entertain children and adults in many environments. As an elementary school counselor, he used puns with kids daily to help teach them language, humor, and to bring levity to sometimes tense situations. As a Coach of youth sports, Dad used puns to connect, and keep the attention of otherwise easily distracted youngsters.

While puns can seem silly to many people, he has found ways to make them much more useful.

And while this book only contains a few handfuls of Dad's puns, I can almost guarantee he's come up with a new one today. He drops new ones in conversations all the time. It's not uncommon for me to hear him use a pun in a group conversation and notice no one even caught it. We love those moments together. This also tells me he's probably slipped countless puns by me. I get cracked up just thinking about dad giggling to himself later, knowing he used an undetected pun.

When I hear puns, particularly "good" ones, I often become curious: *How has no one said that before?*

Perhaps they have.

When Dad shares a new pun with me, he'll usually preface it with, *"As far as I know, this is a new one. At least I've never heard it before"*.

Then Dad might make mention of his old Italian buddy, Farazino.

If you're the type of person who tries to pretend puns are just silly "Dad jokes", not "really" funny, and insignificant...

before you turn the page...

 just go ahead and…..

Roll Your Eyes Now

Why did the little boy with a bad cold ask his daddy to build a barn?

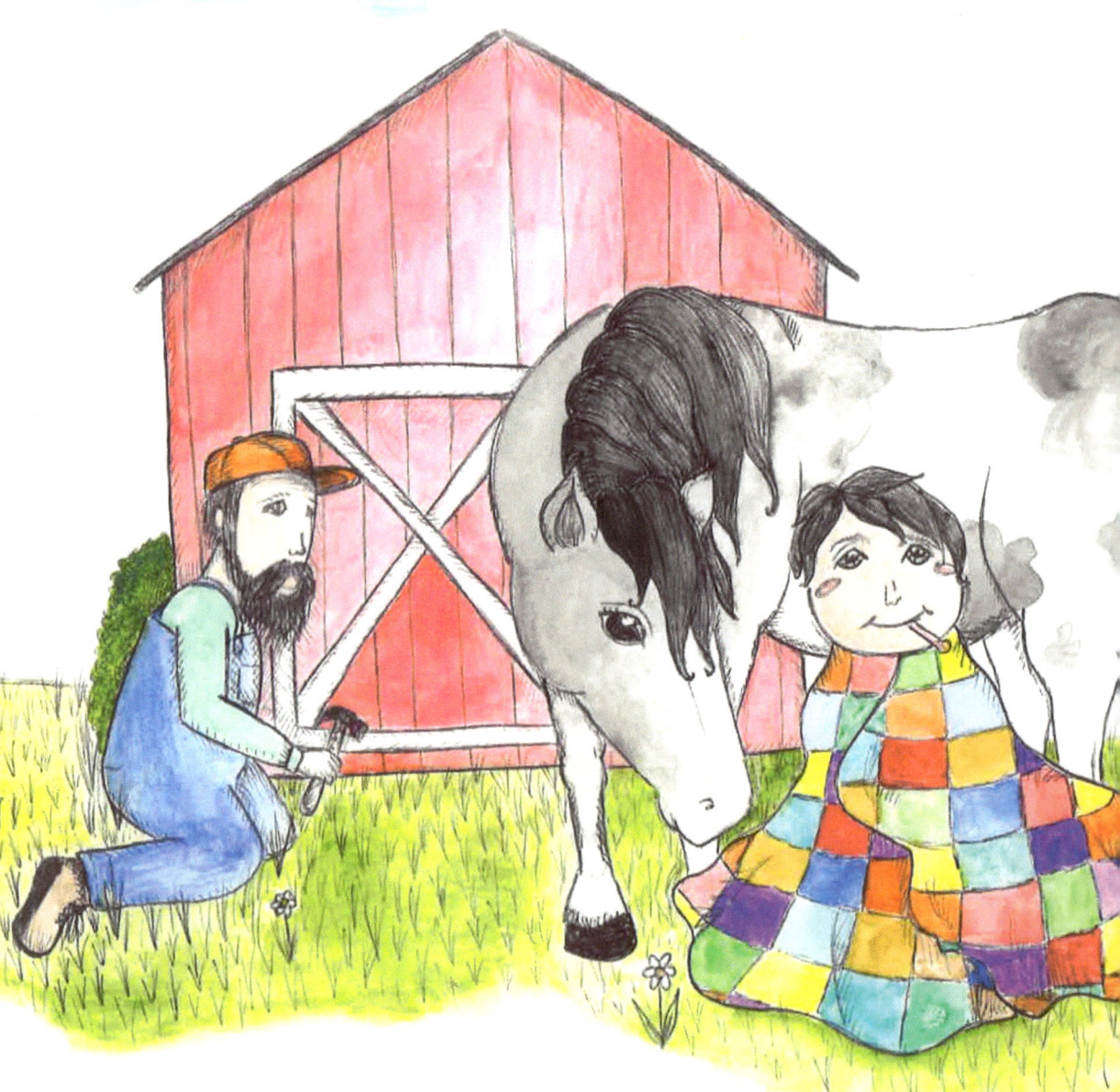

He had heard that sometimes
when you get a cold
you will get a little horse.

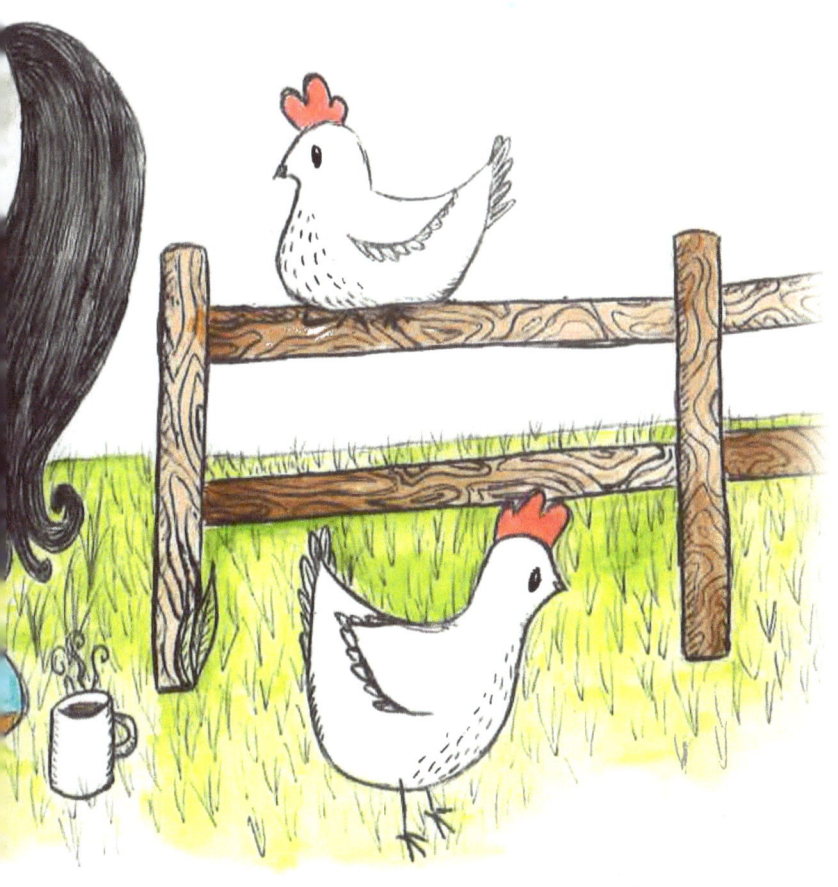

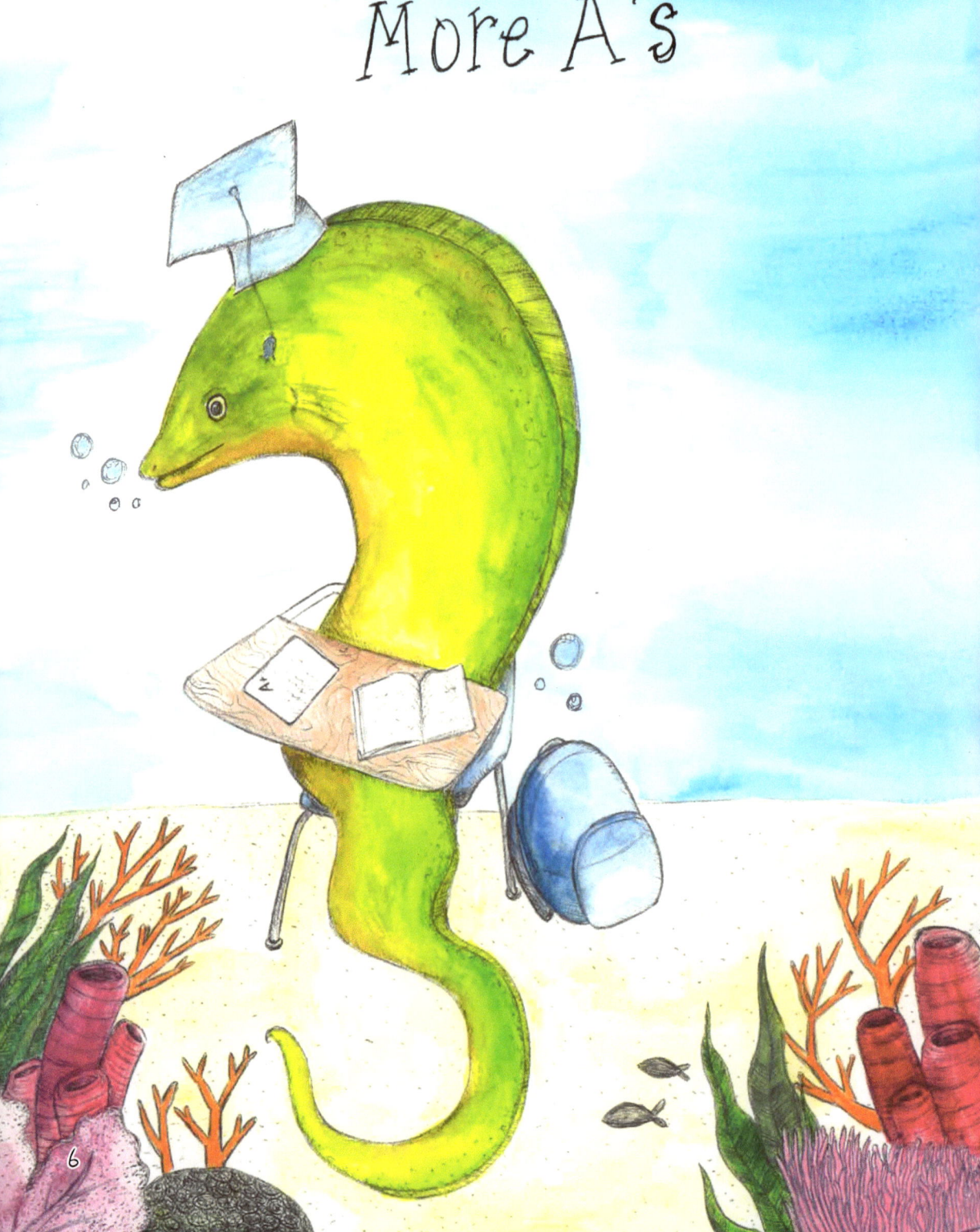

How can you tell that cowboys think they can Control the Weather?

They spend a lot of time holding onto rains.

my friend is a
Buck an Ear

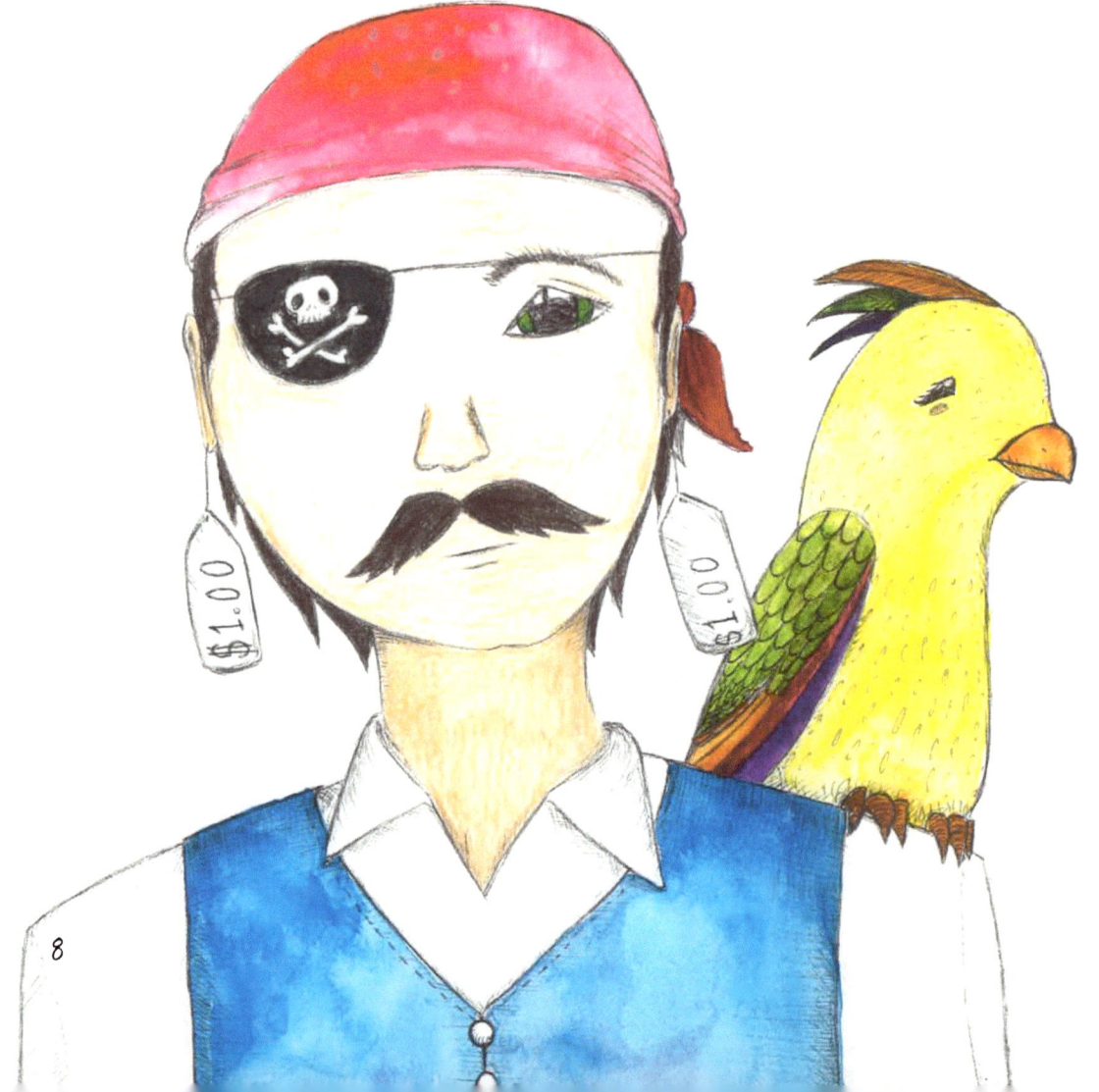

Something tells me you're not telling the truth.

Why do you say that?

I just feel your line to me.

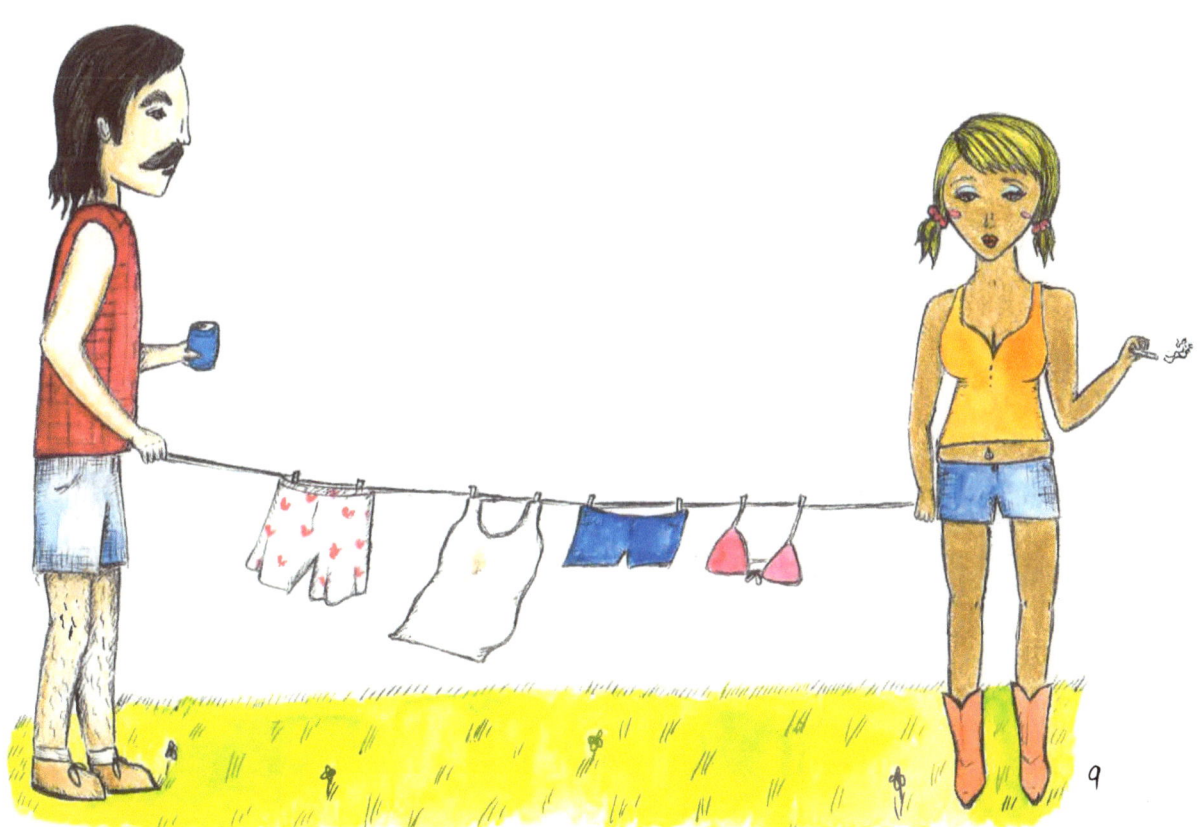

How can you tell that Cabbage is a success-oriented plant?

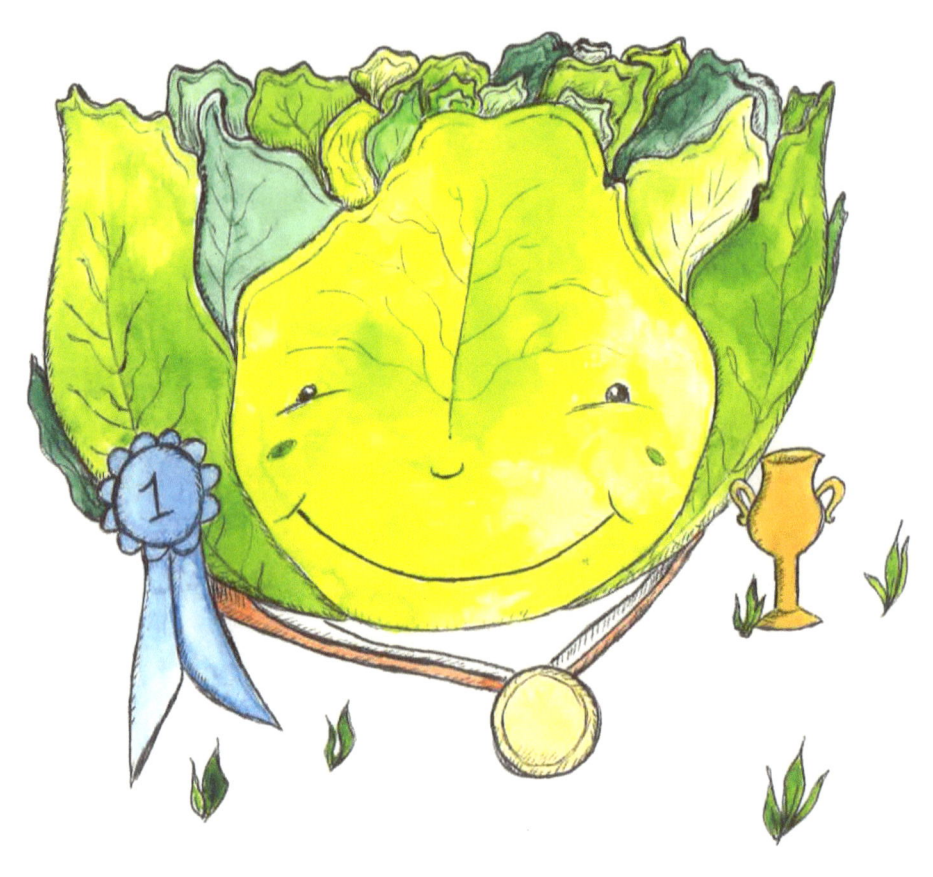

It spends its whole life trying to get a head.

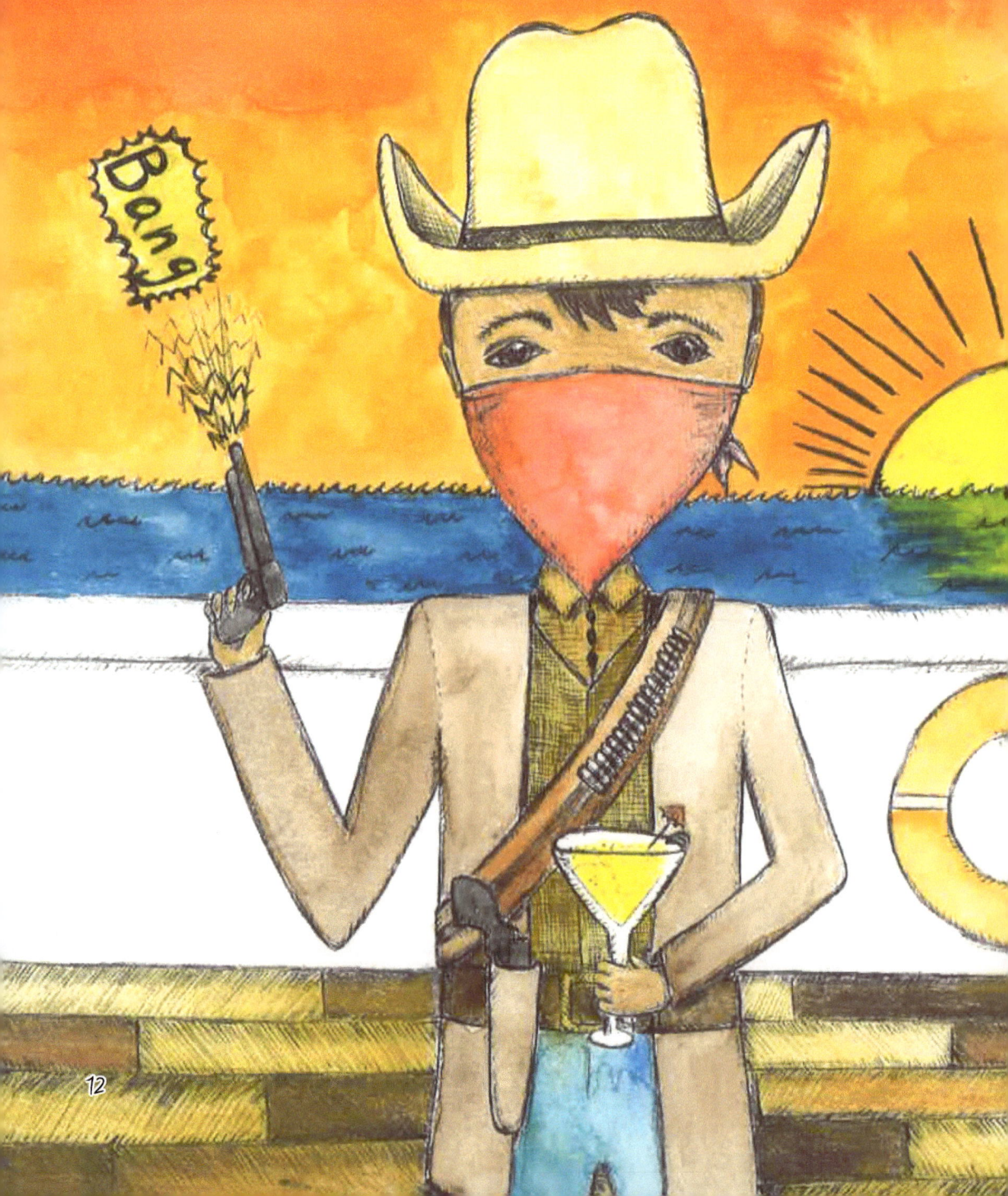

The gunslinger will shoot from the hip.
The owl will hoot from the ship.

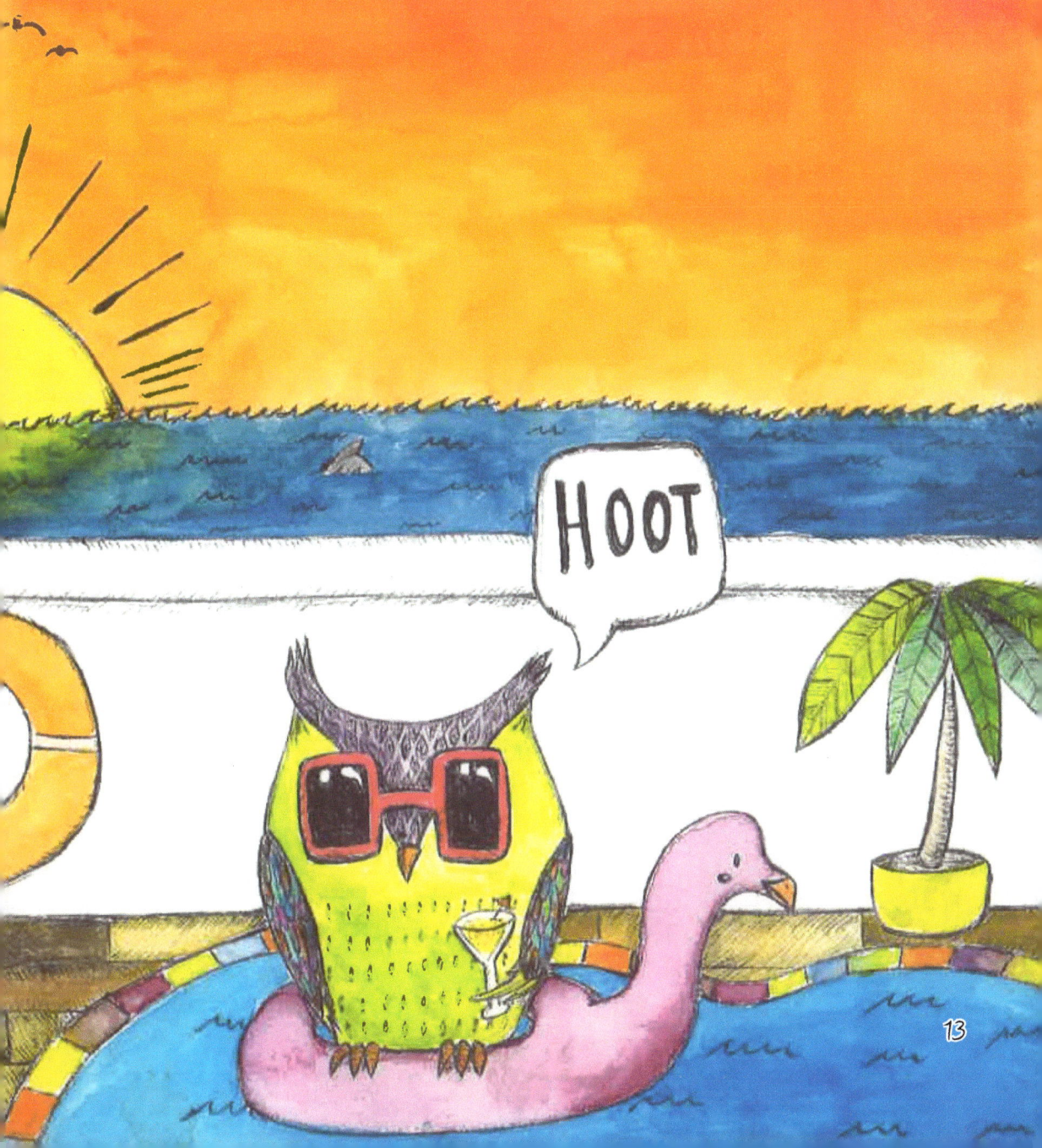

What is the major difference between a door and a jar?

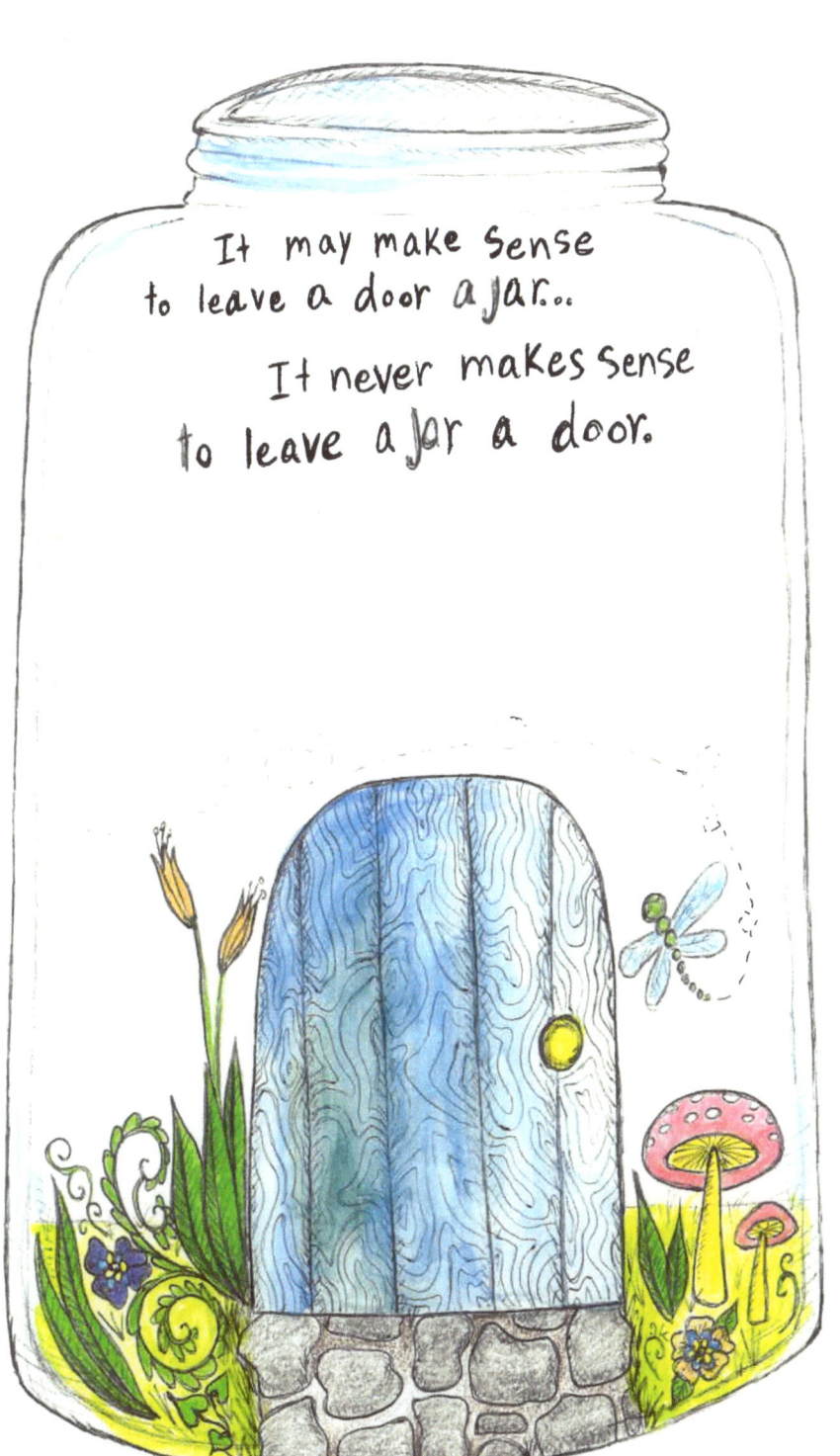

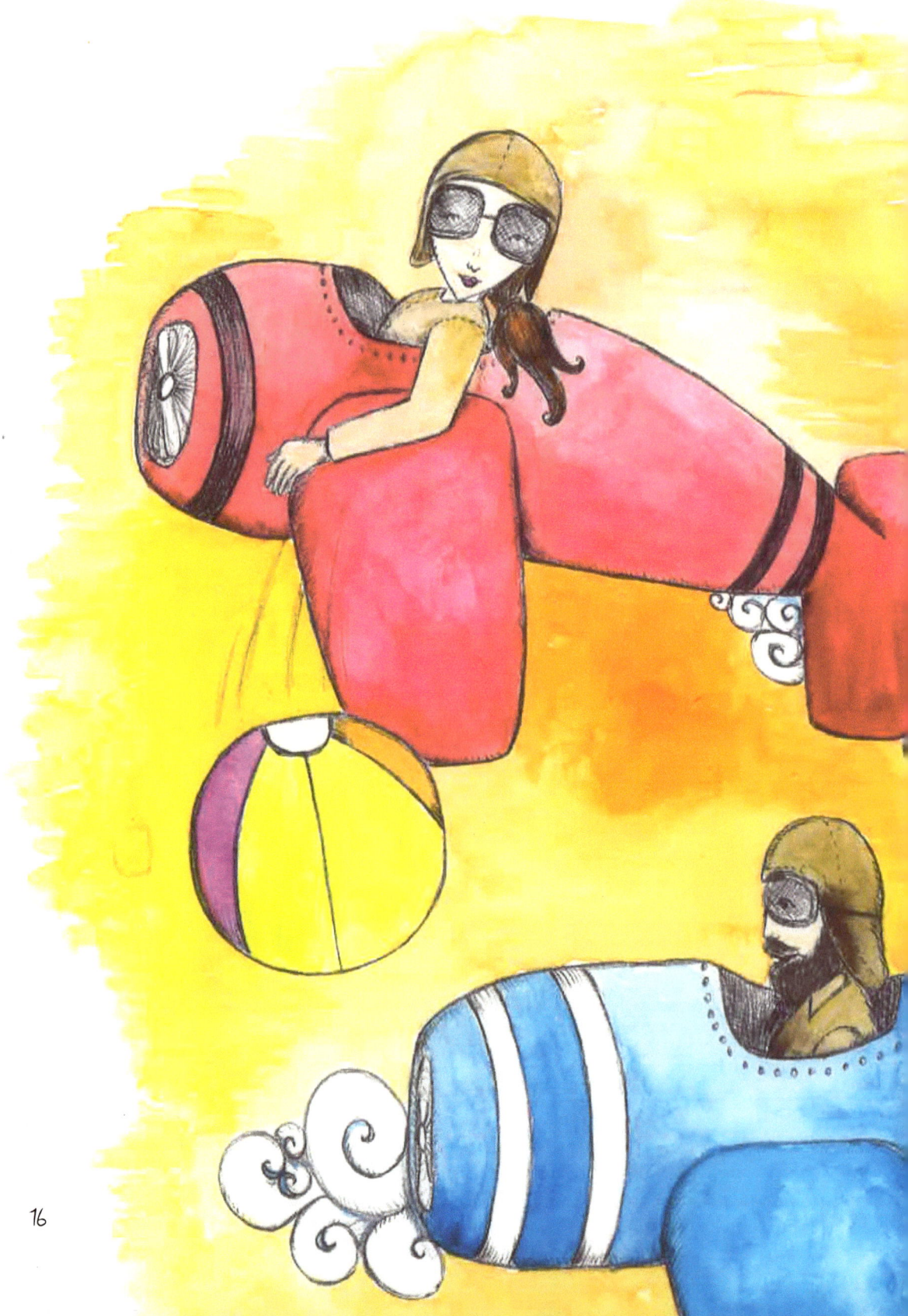

Why is it so easy to entertain pilots?

They like plane fun.

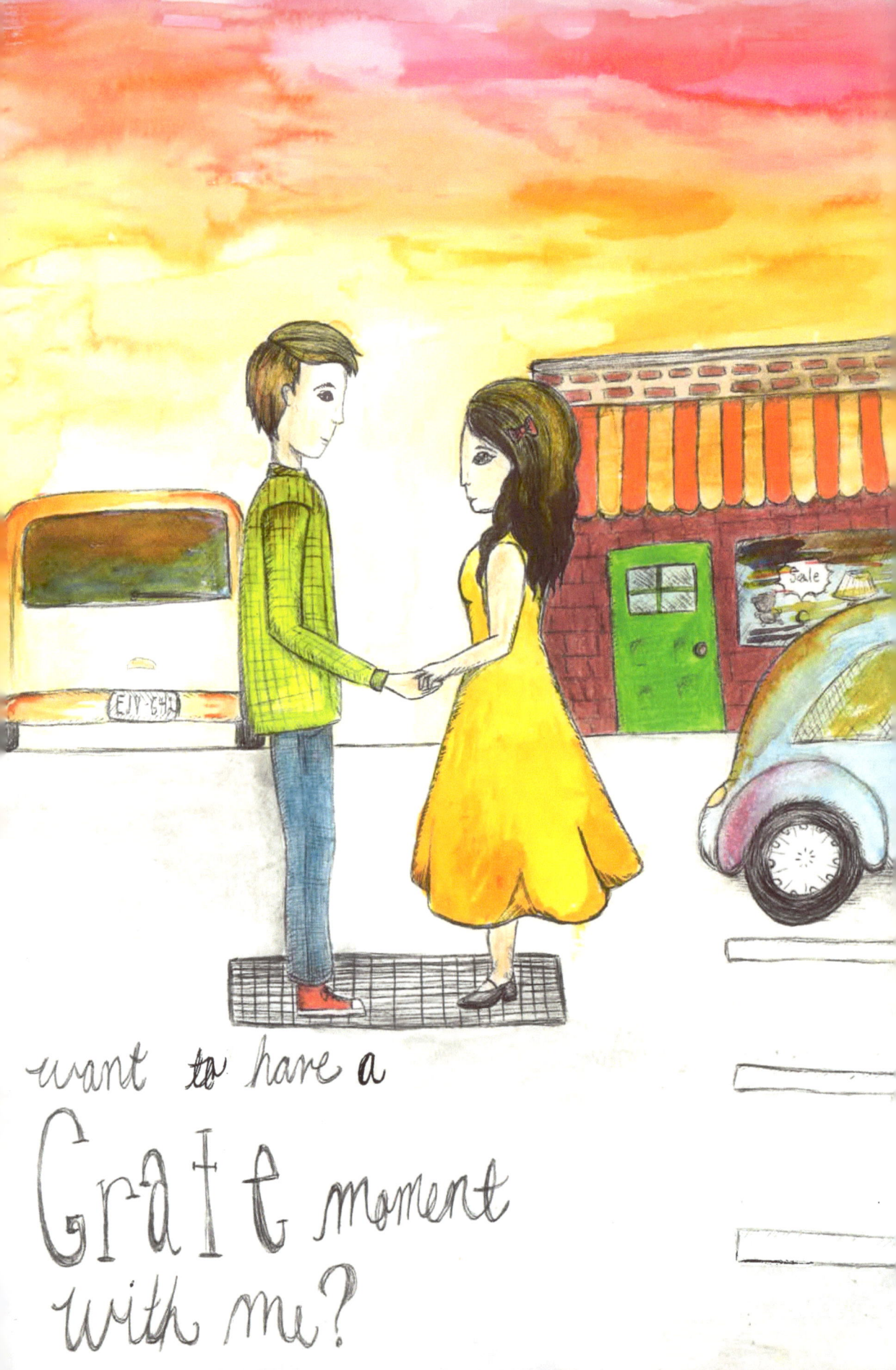

How is a baseball game similar to a bakery?

They both depend on getting the batter up!

Why should a woman keep a change of clothes in the trunk of the family car?

So when they have a flat tire
She can change attire
While her husband changes a tire.

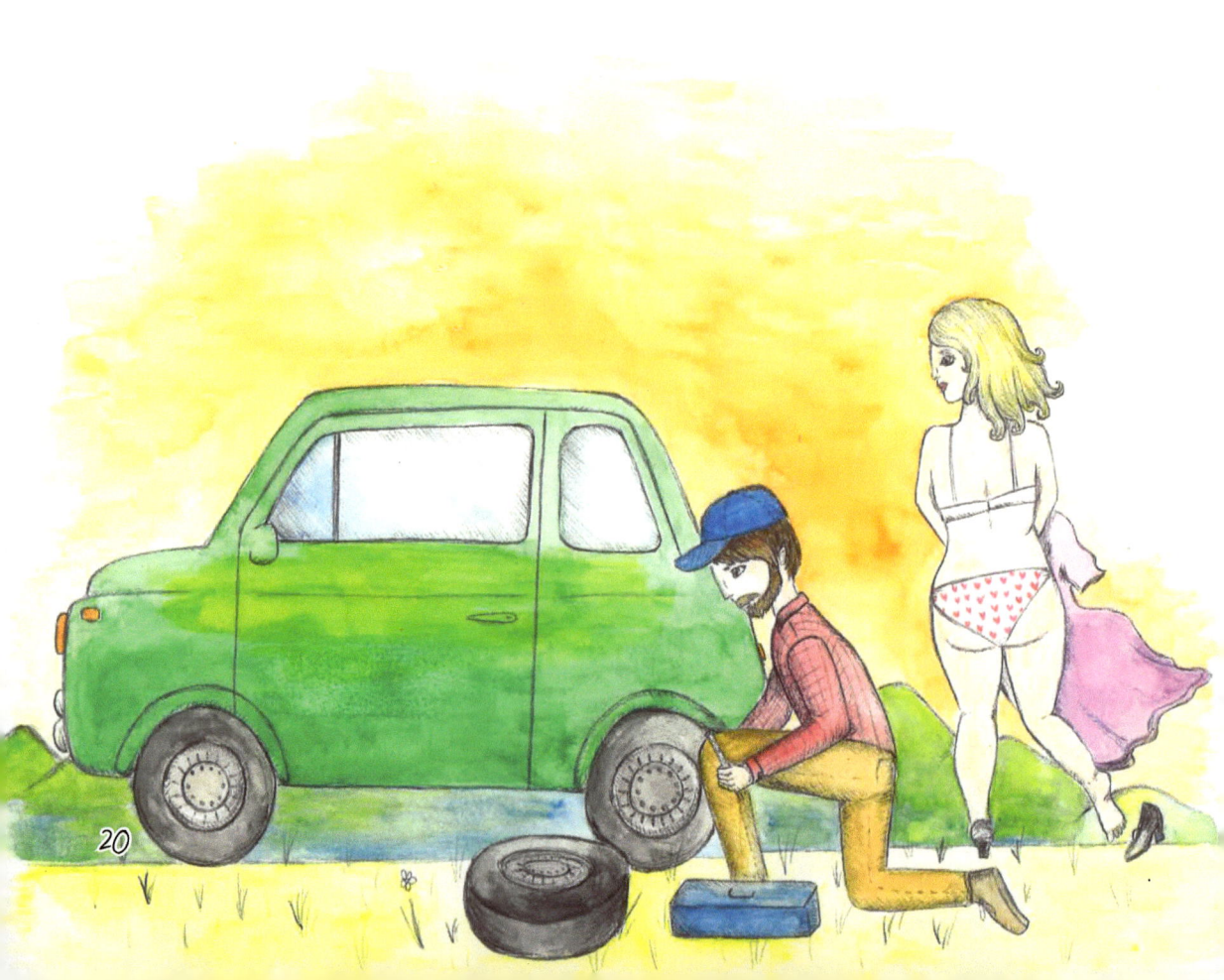

How do you know when a fattened hog is lying? When he starts singing "Lean On Me".

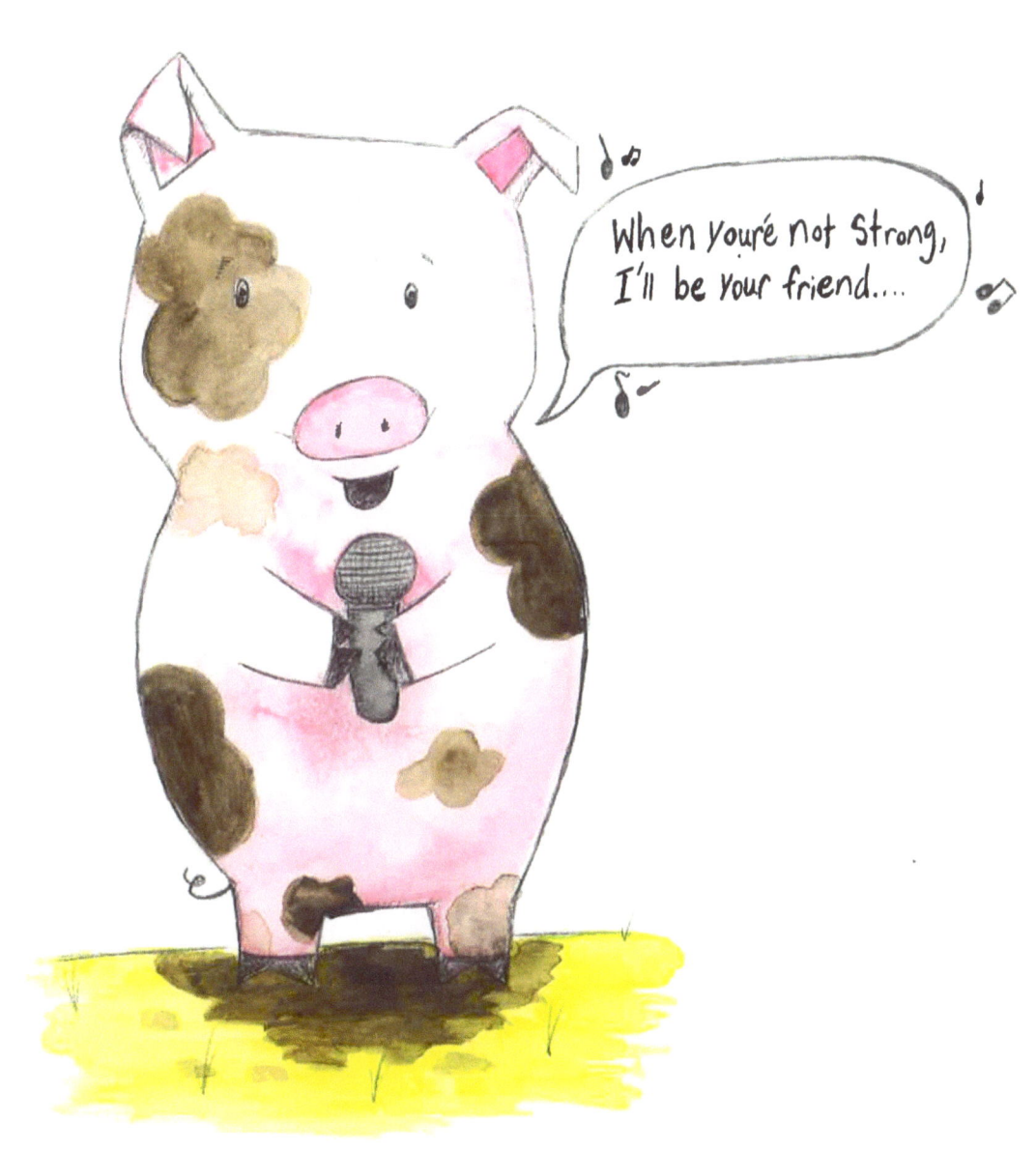

What is the favorite

sport of lawyers?

Sue-mo

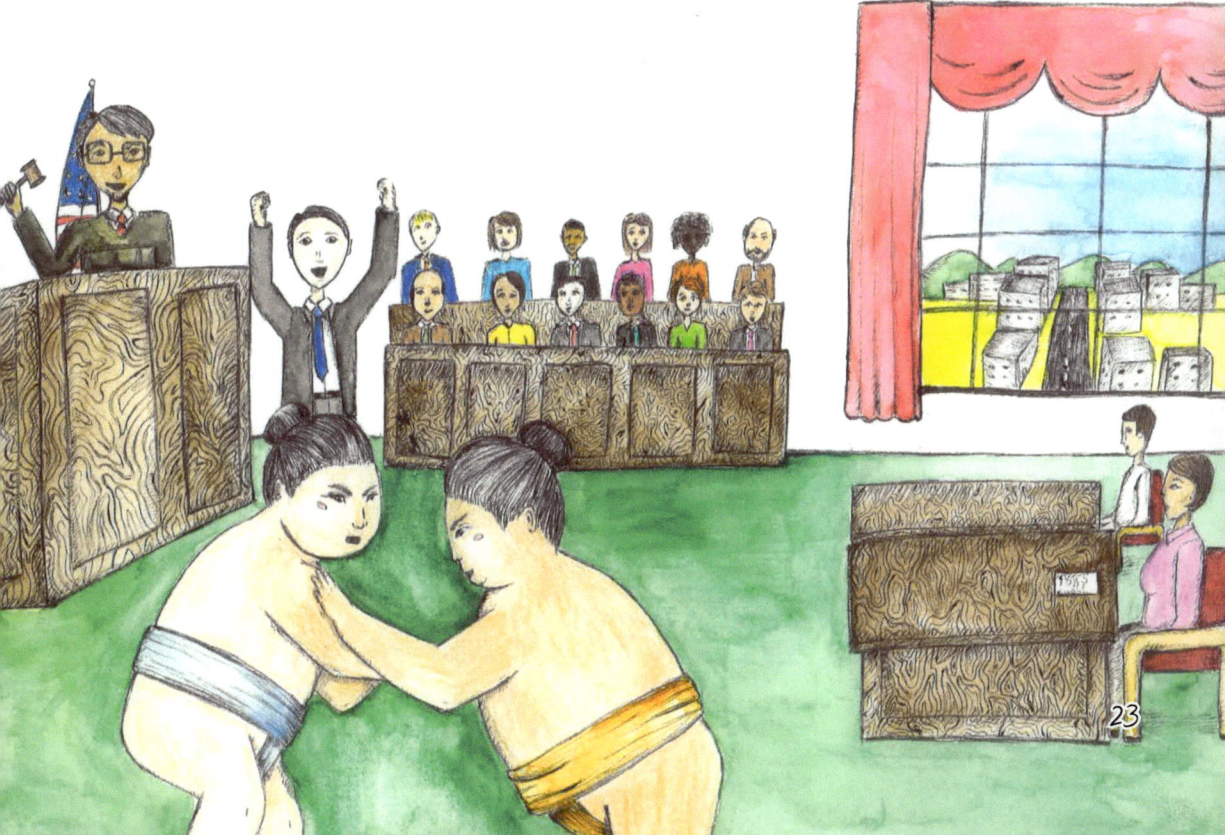

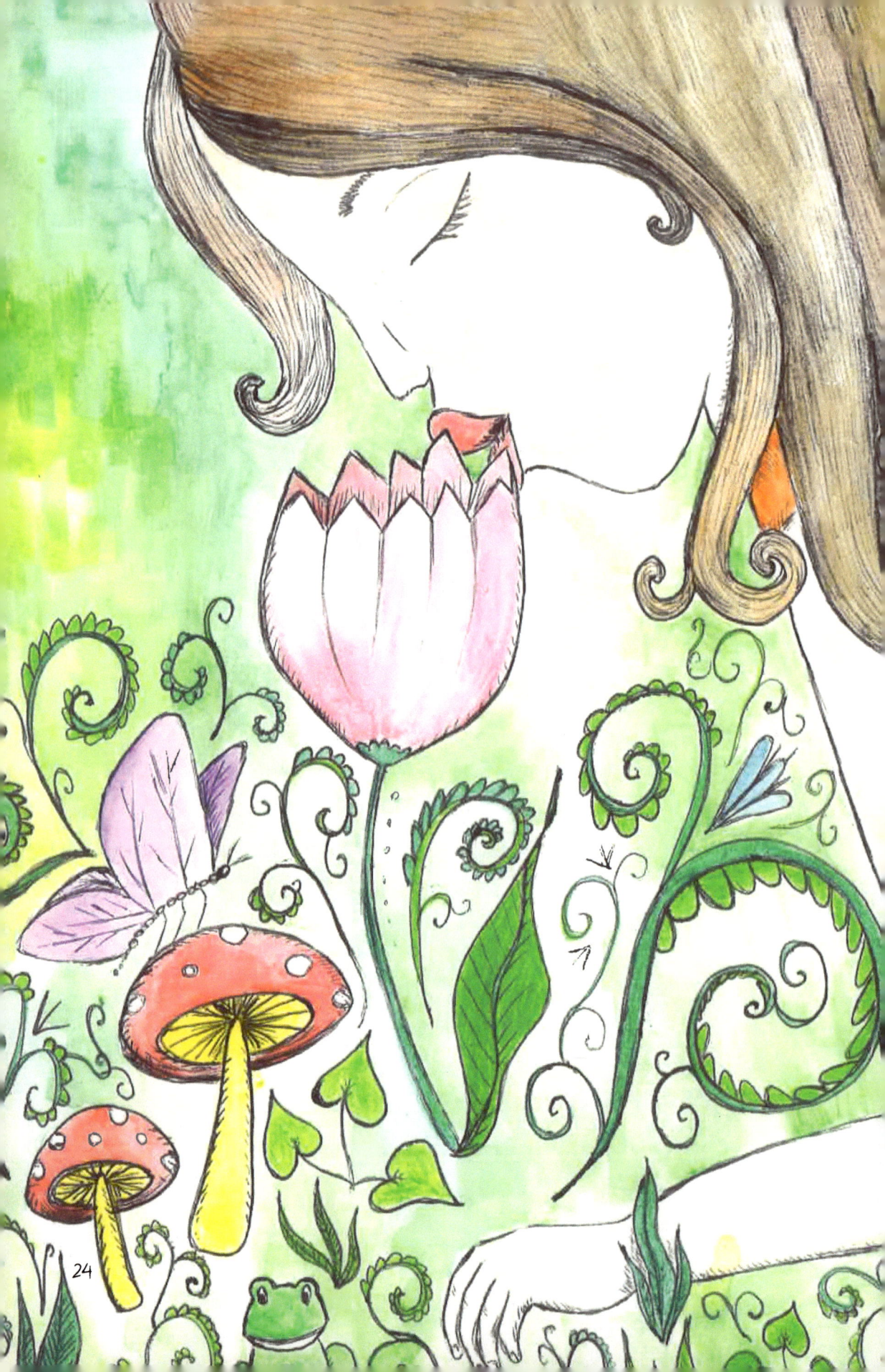

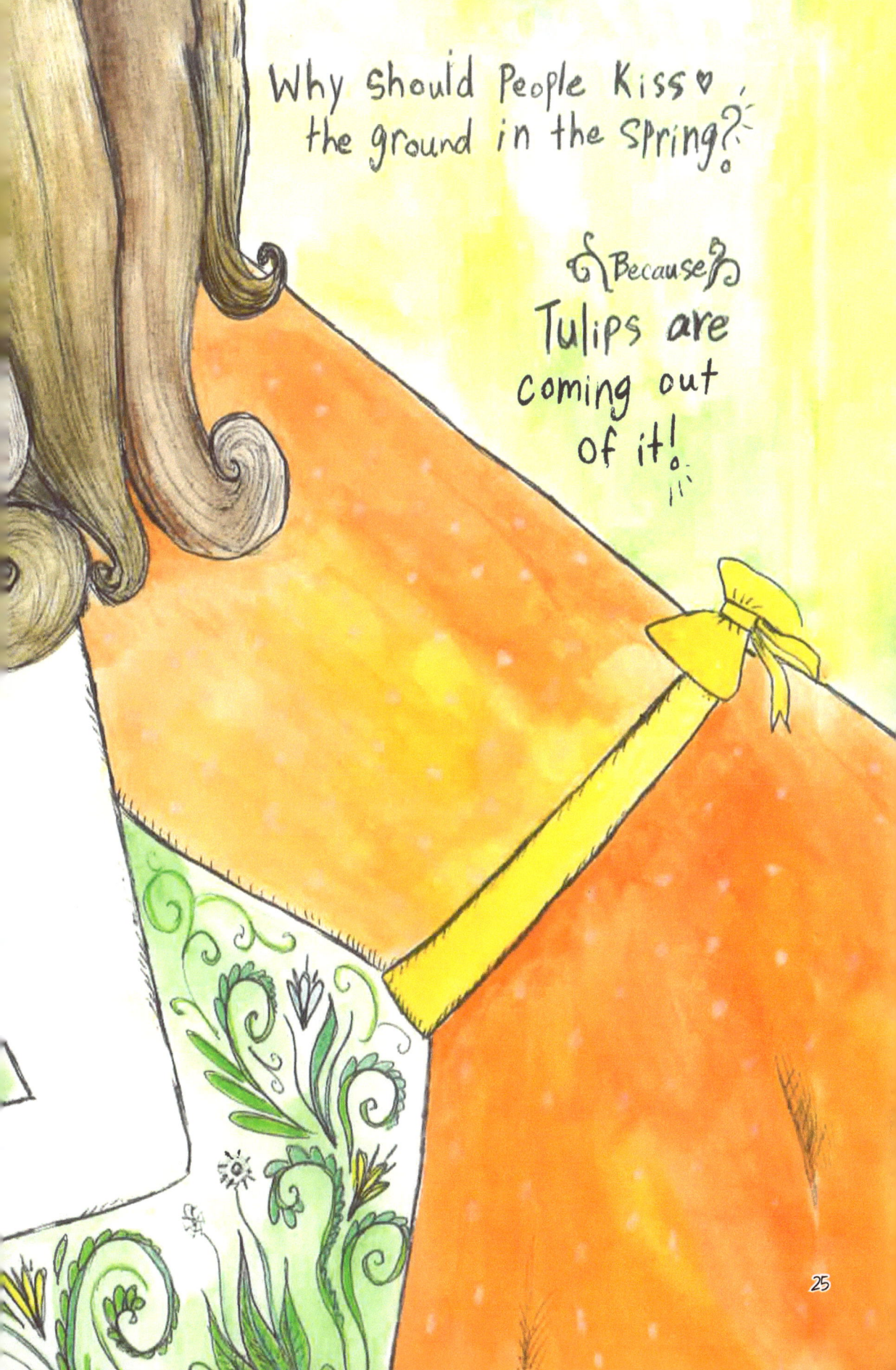

They say we reap what we sow.
If we row a boat with a small hole in it,
we seep what we row.

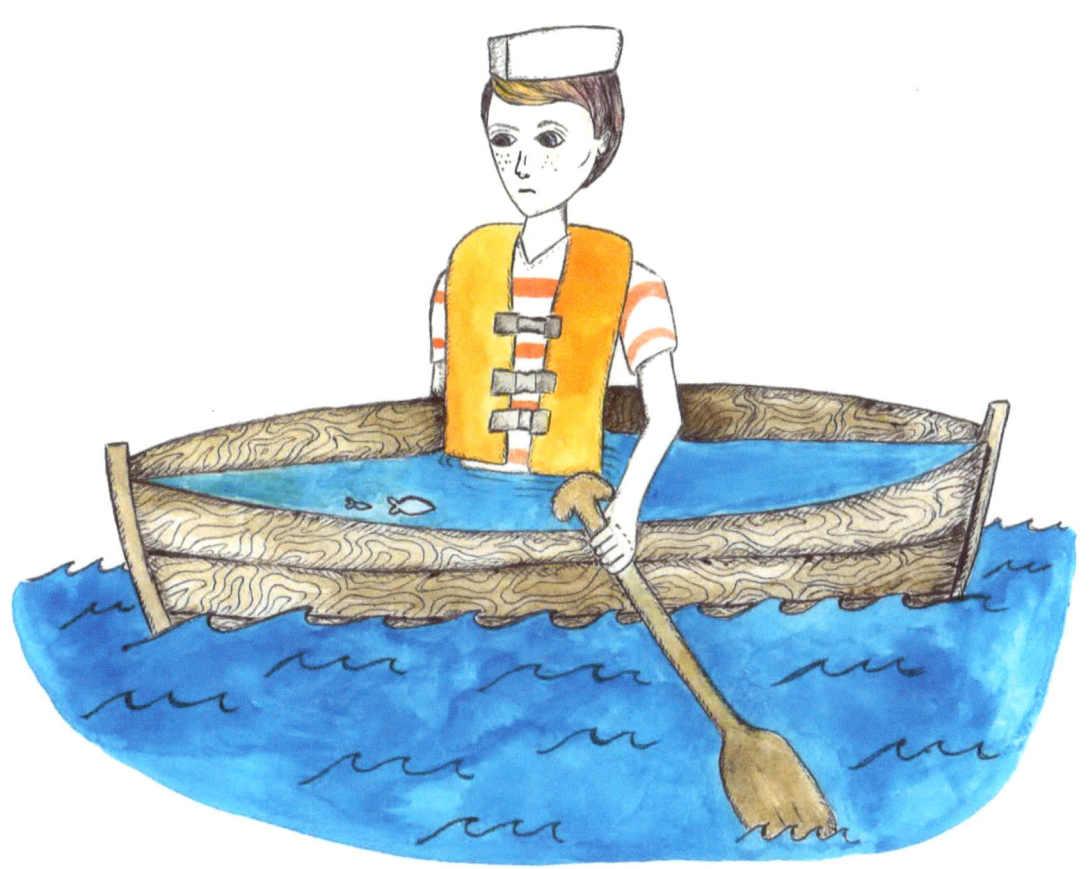

Can you draw
 a pioneer?

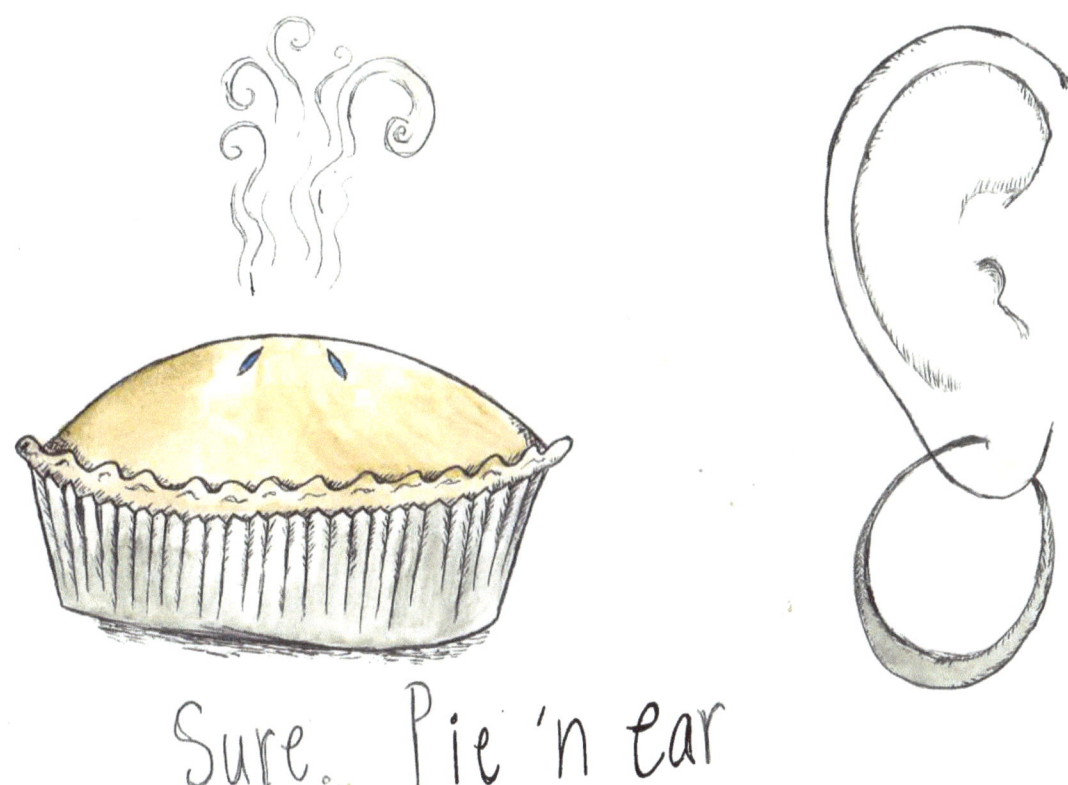

ABOUT THE AUTHOR

A native of Jackson County, Dave Waldrop was born and raised a couple of miles from Sylva, NC, on October 14, 1943. After graduating from Sylva-Webster High School, Dave went on to serve in the Navy for four years. Upon his return to Jackson County, Dave, utilizing the GI Bill, began studying at Western Carolina University. He went on to earn both a B.S. in Psychology and a M.A. in Counseling. This education led to a thirty-year career as a counselor, coach, and mentor to thousands of elementary students. Dave Waldrop has always had a curious mind and a penchant for travel. This hunger for knowledge and experience has led him to Japan, the Philippines, Midway, Hong Kong, Canada, and 48 of the United States of America. The same intellectual drive now feeds his many passions as a published poet, essayist, songwriter, and historical author. Dave Waldrop still lives in Sylva with his beloved family.

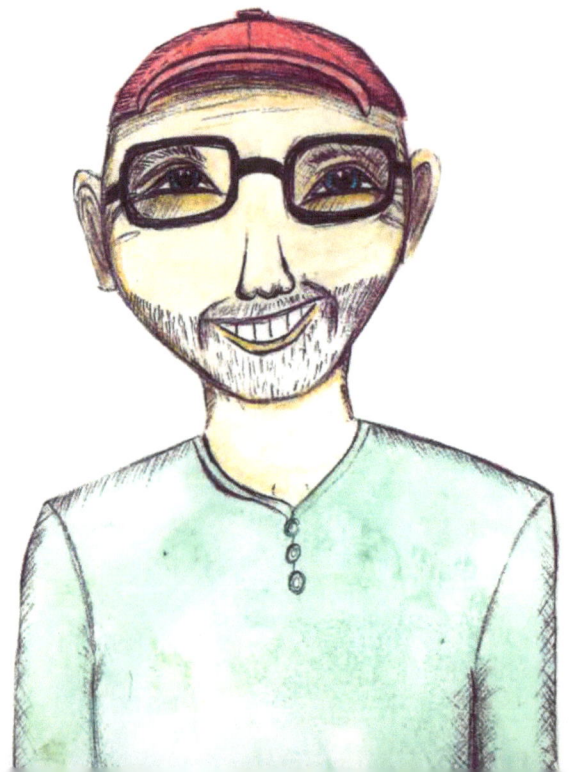

ABOUT THE ILLUSTRATOR

When Alma Russ was four years old, she told her parents that she wanted to be an "arter" when she grew up. She did become an artist in a variety of ways. Alma is a songwriter and plays fiddle, banjo, and guitar. She has collaborated on a variety of recordings as well as made her own album titled Next Town. Alma shares writing about her adventures in being a traveling musician on a blog almagail.blogspot.com. Alma is also a visual artist who enjoys sculpting, drawing, and painting. When Alma is not traveling, she lives in Whittier, North Carolina.

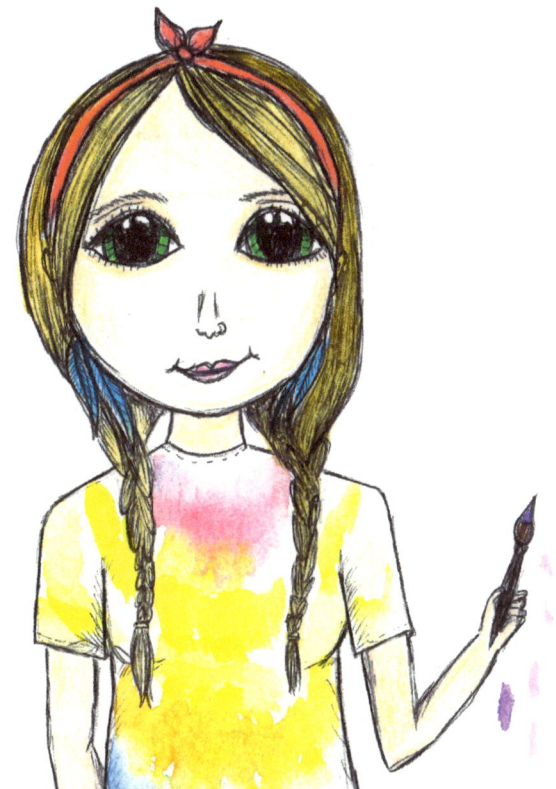

Other works by Dave Waldrop

Freedom
2002-Twenty-nine poems and songs

Am I
2005-A collection of poems by Dave Waldrop
and his mother, Lillie W. Pannell

Appalachian Roots
2010-Dave Waldrop biography combined with
Michael Revere's collection of poems

1961 Sylva Senior League Baseball
2012-A limited edition of the story of Sylva playing in the
inaugural Senior League Baseball Tournament in Williamsport,
Pennsylvania

Saving These Sacred Mountains
2014-A compilation of presentations advocating for protection
of the Balsam, Blue Ridge and Cowee Mountains surrounding
Jackson County, N.C.

Song of Socrates
Ca. 1990-An educational game using popular songs to develop
listening skills, memory, confidence, and reasoning

CPSIA information can be obtained
at www.ICGtesting.com
Printed in the USA
LVHW071609210222
711637LV00002B/147